New stars bright

Angels delight

Being, truth, and beauty

Light and life.

Imperfect though,

Far from high,

Give Glory to the Lord.

Lawrence Nusbaum, Artist

Saatchiart.com
Fineartamerica.com — art

Createspace.com
Amazon.com — books

Santa Fe, New Mexico

lawnus@peoplepc.com

Facebook 505 820 0174

Lawrence Nusbaum copyright 2017

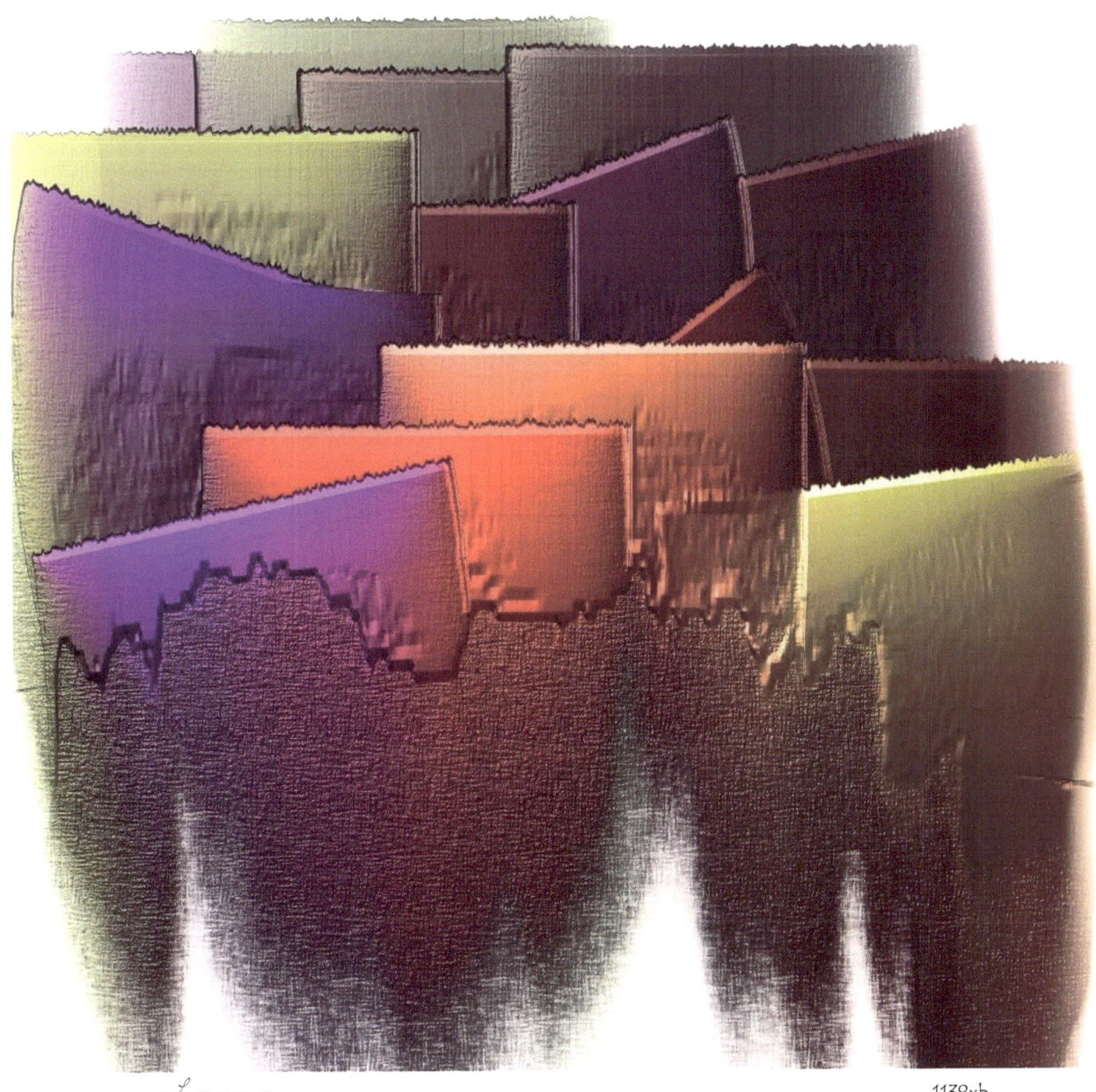

Lawrence 1138xb

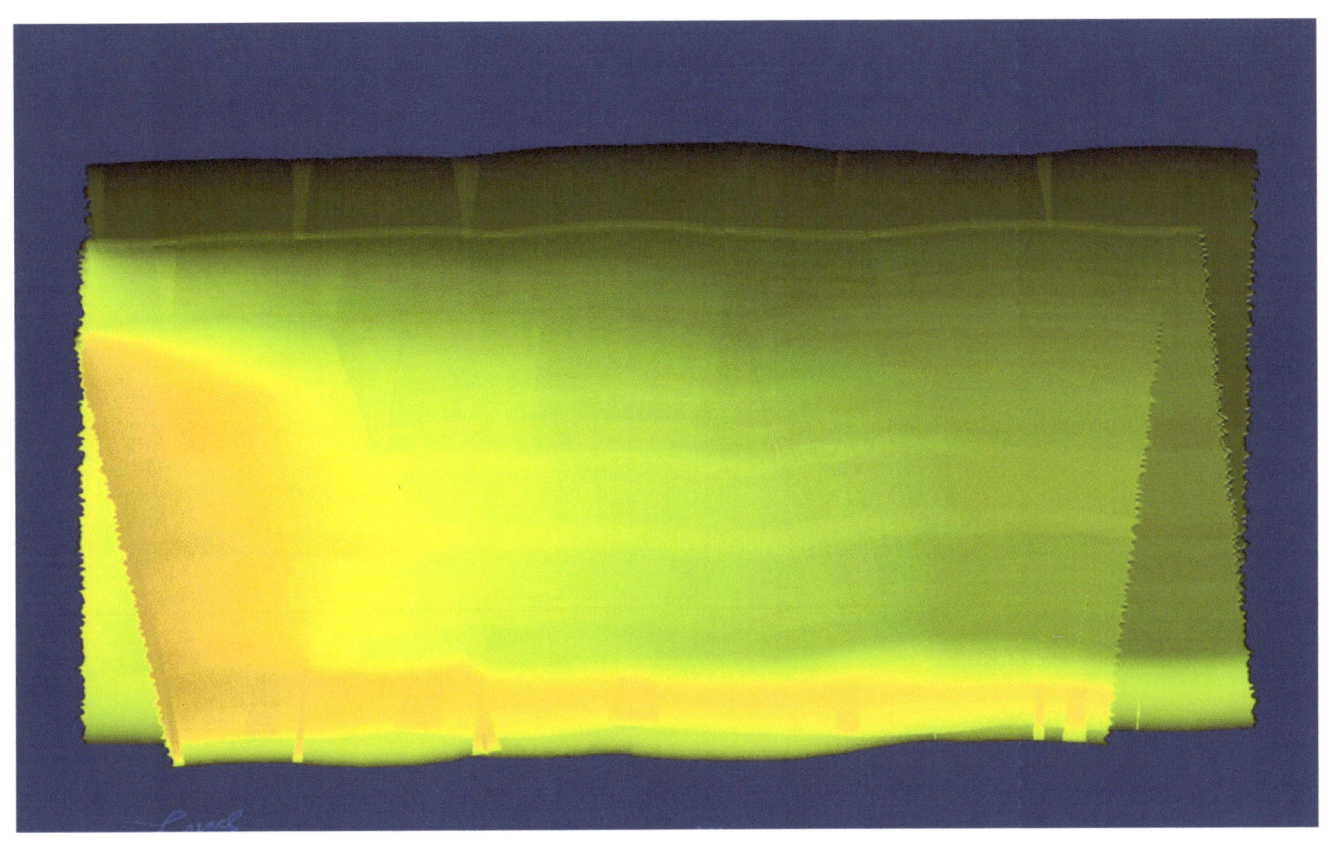

Lawrence 718xc

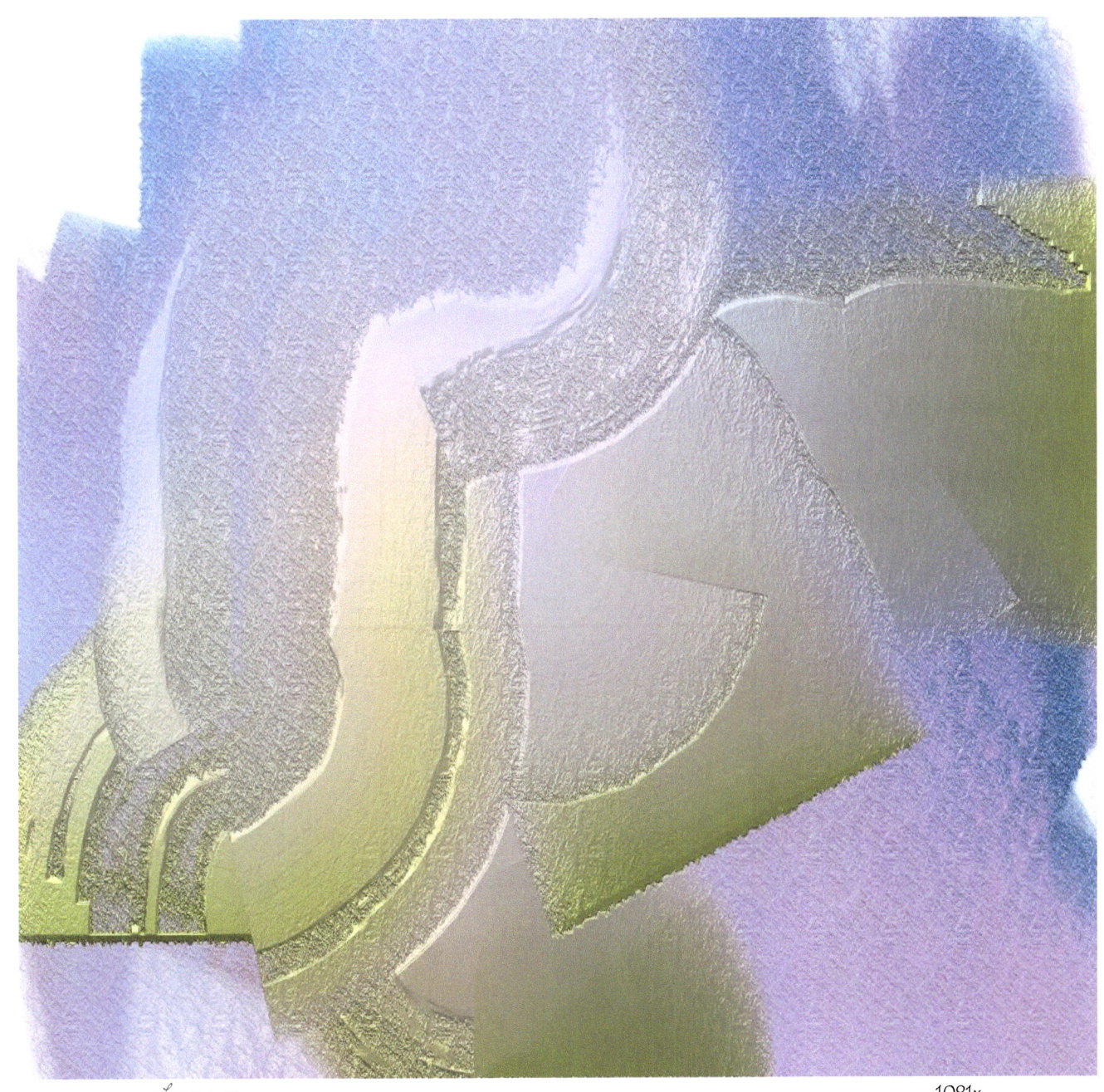

Lawrence 1081x

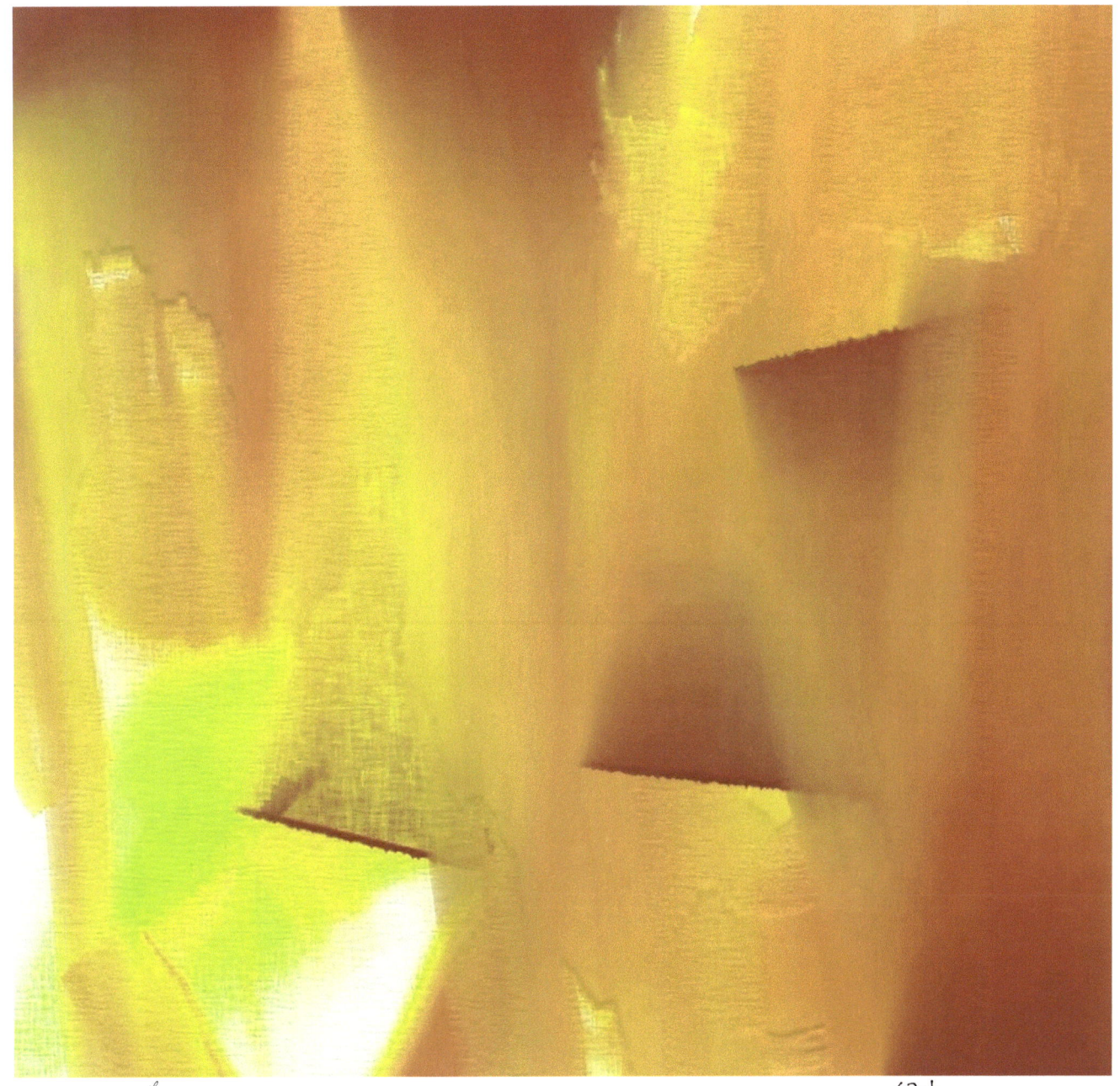

Lawrence 62xb

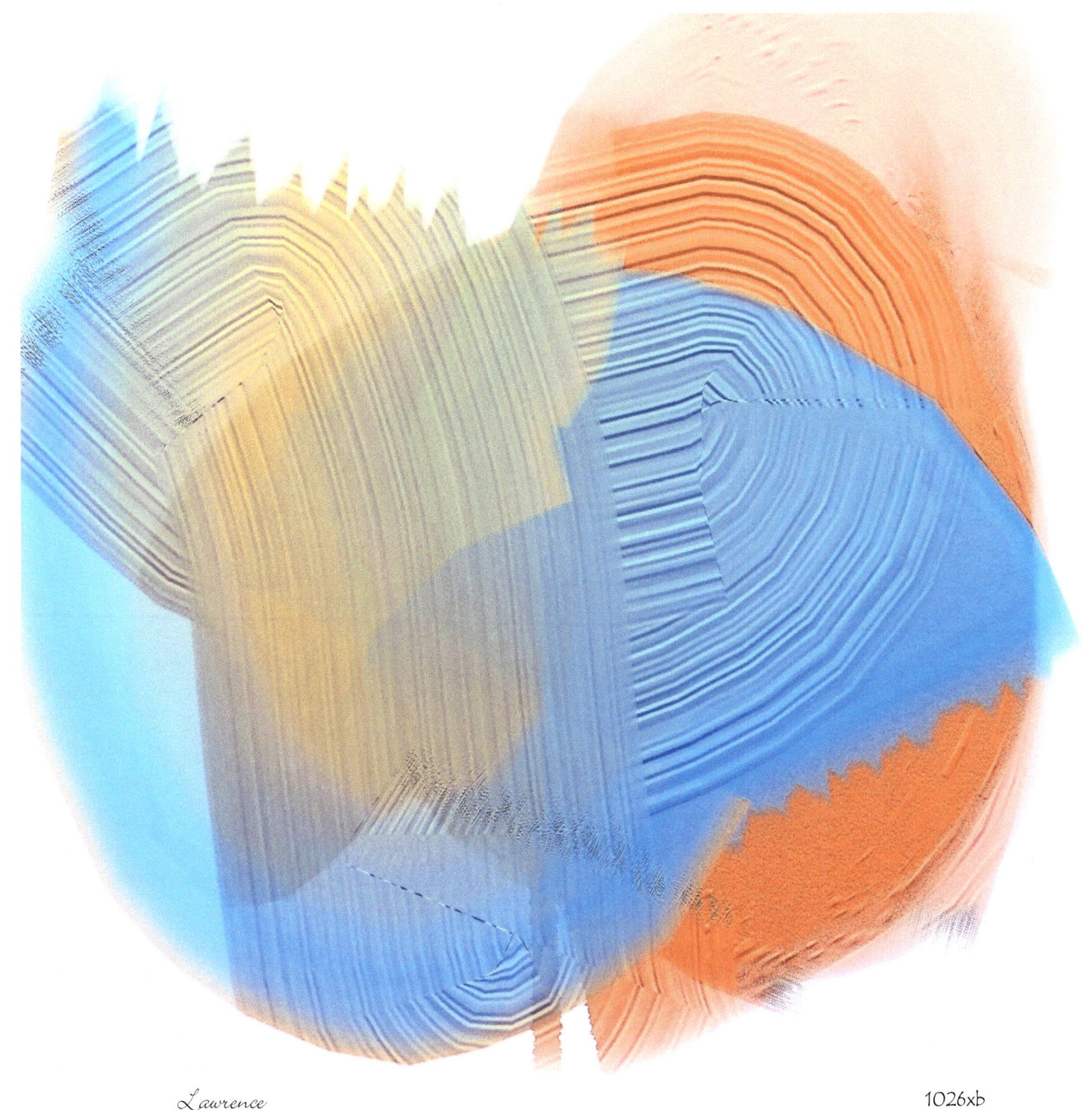

Lawrence 1026xb

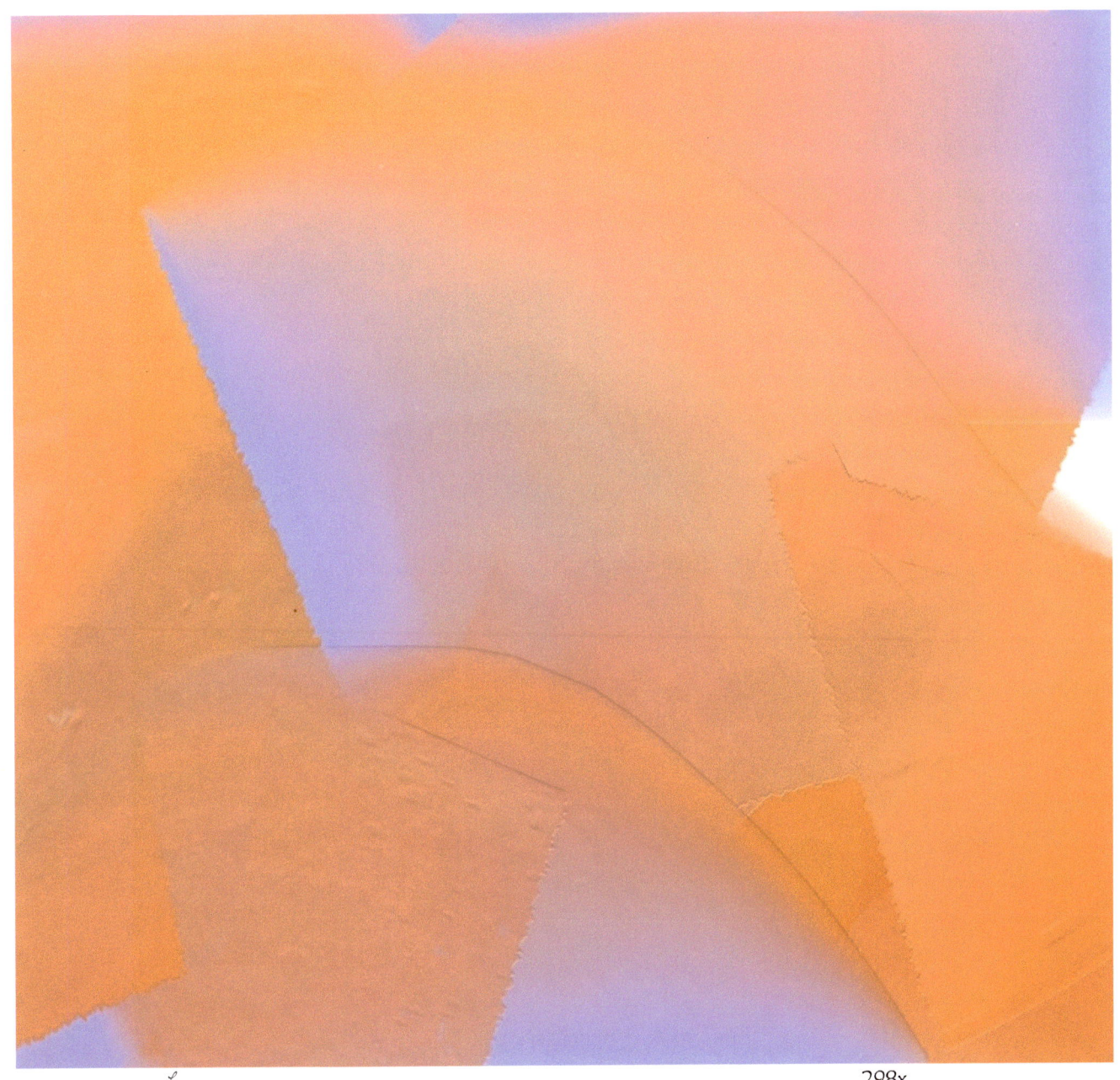

Lawrence 298x

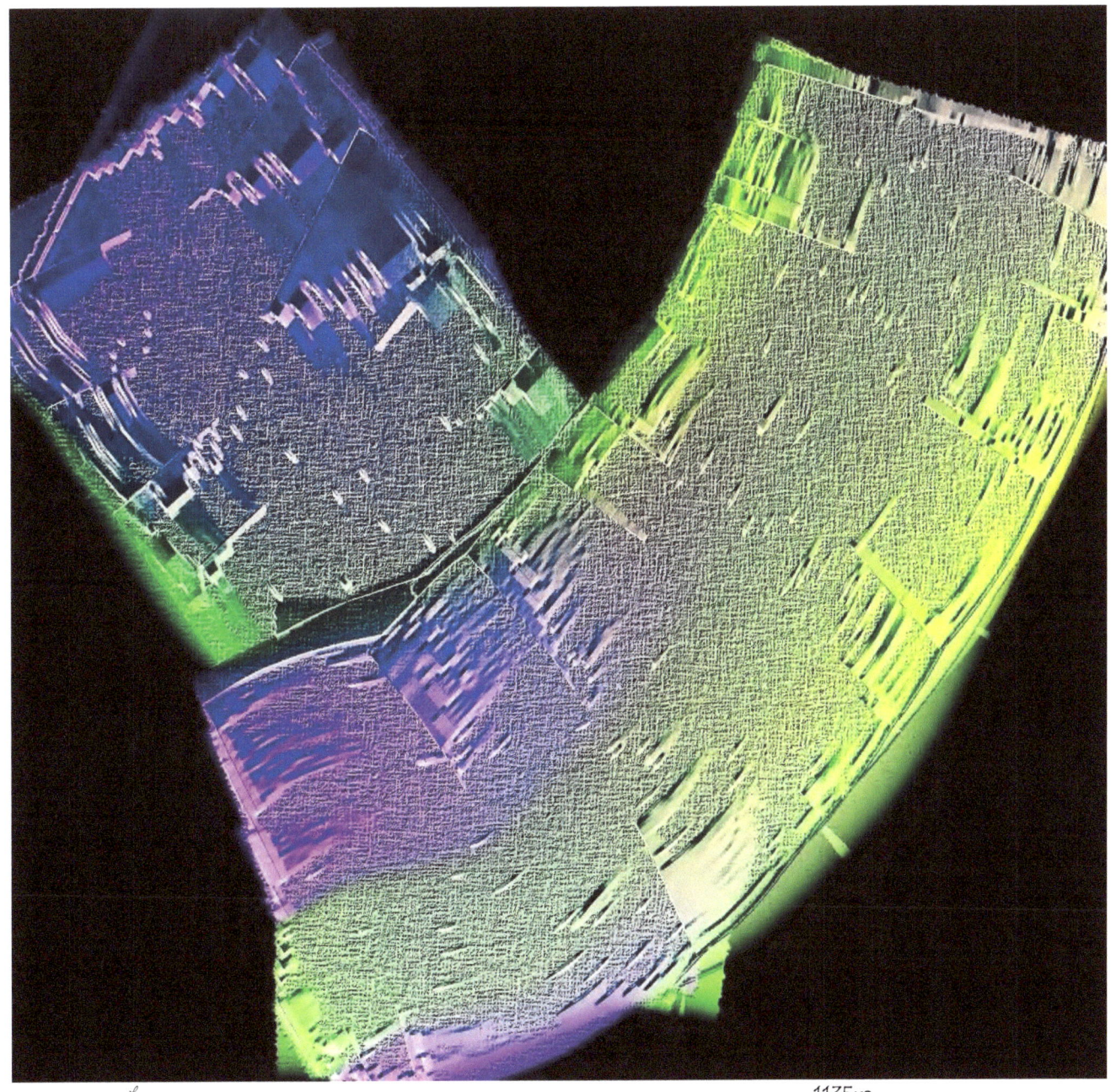

Lawrence 1135xa

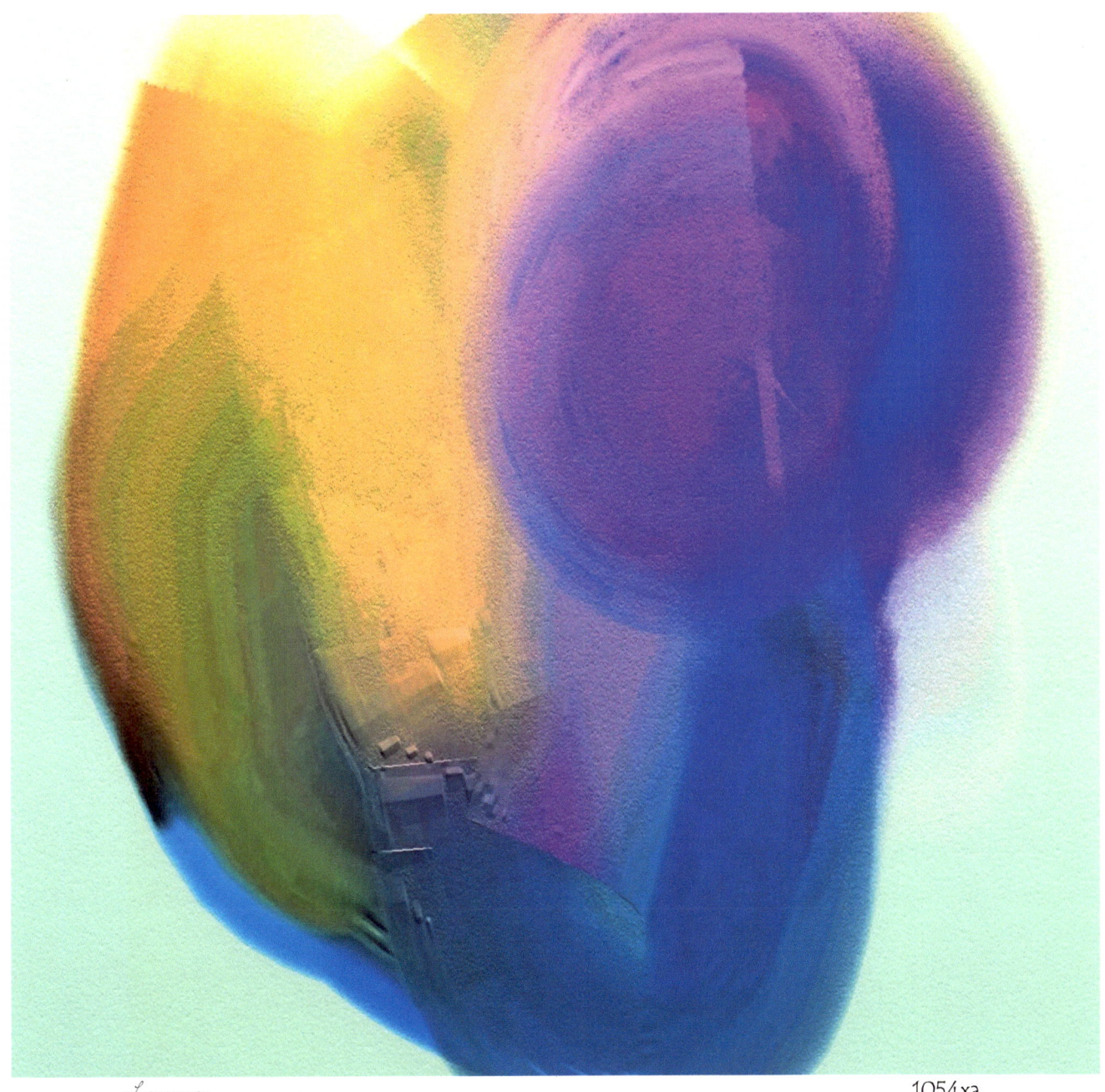

Lawrence 1054xa

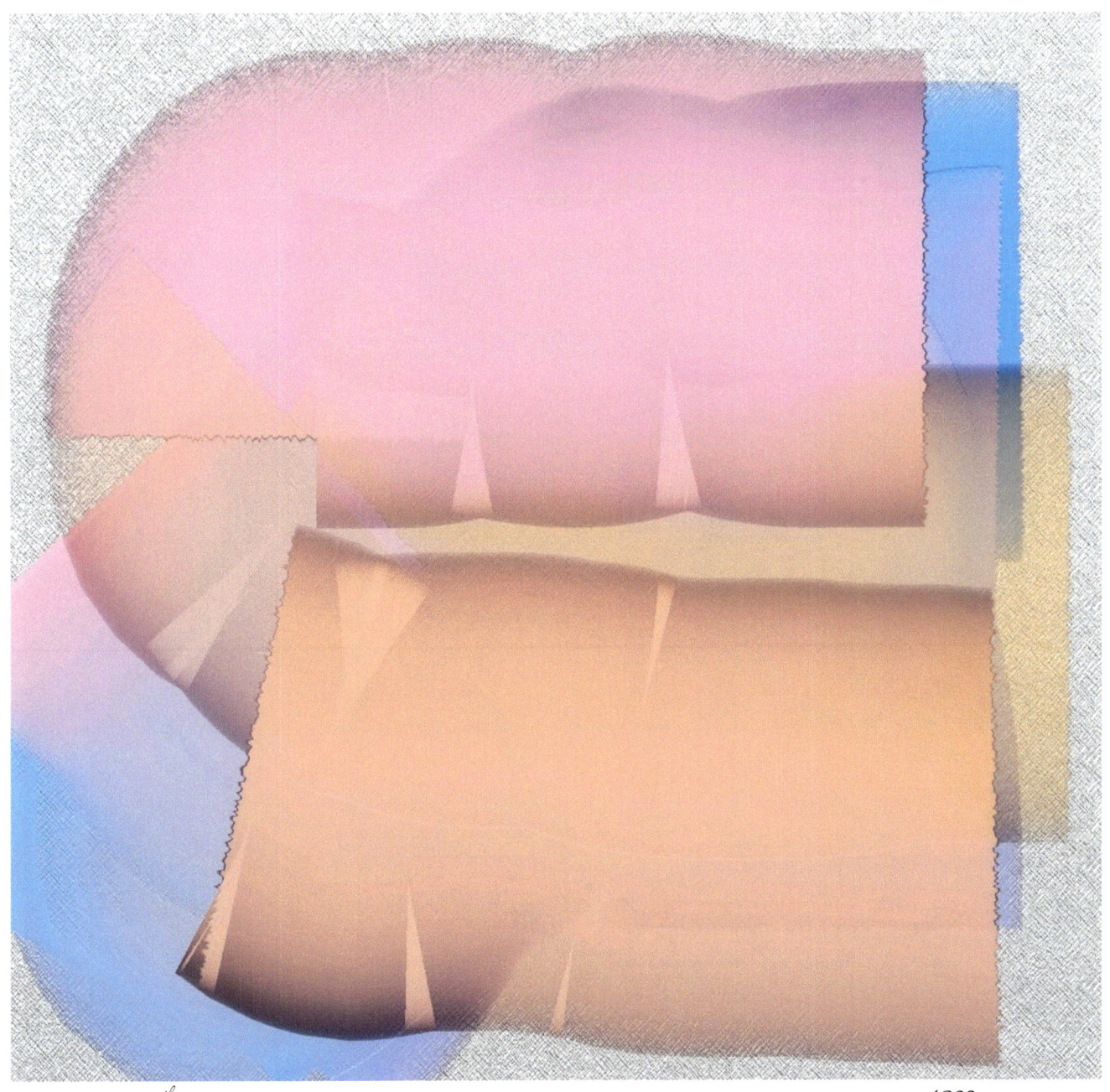

Lawrence 1099x

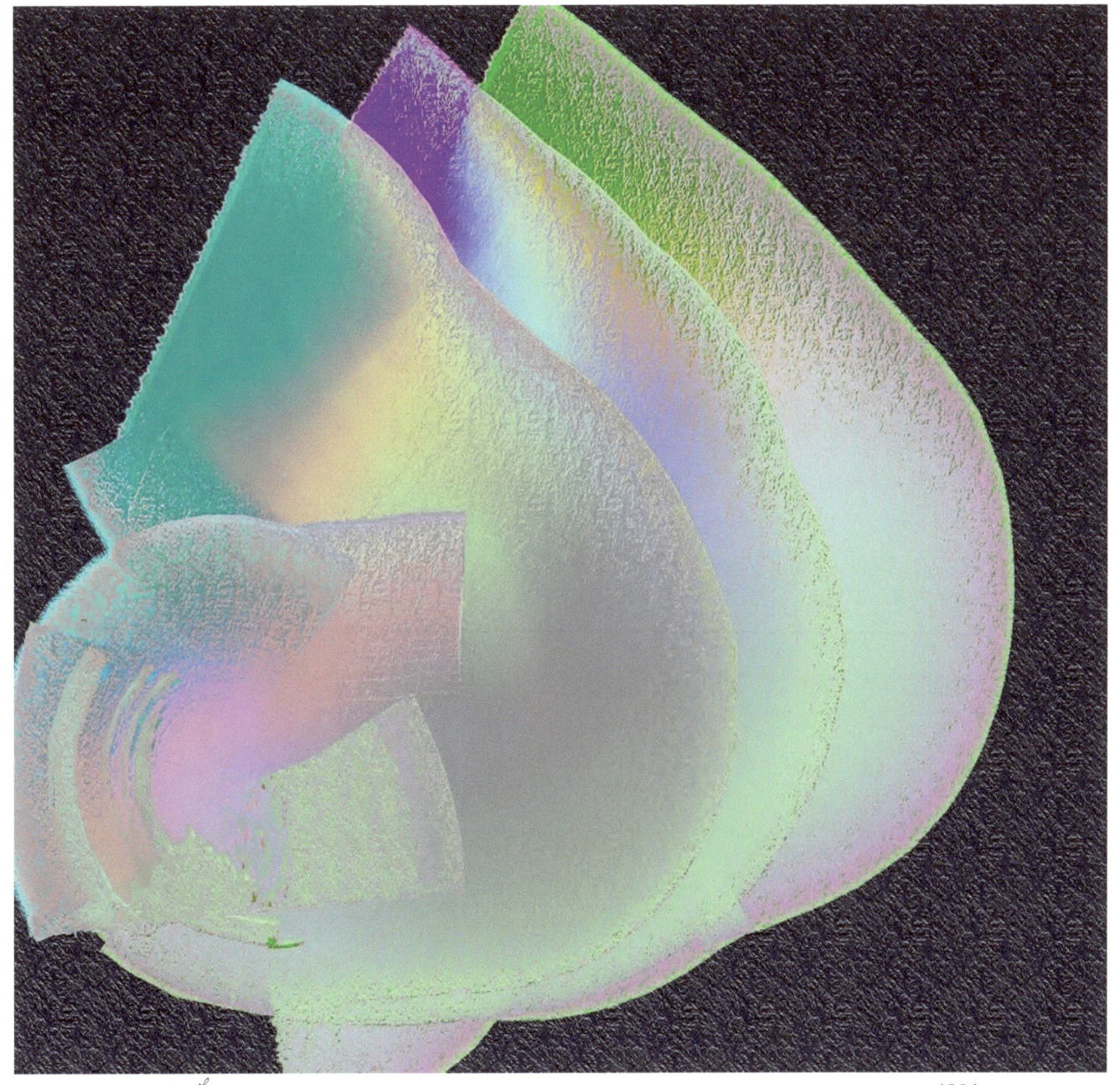

Lawrence 1084xc

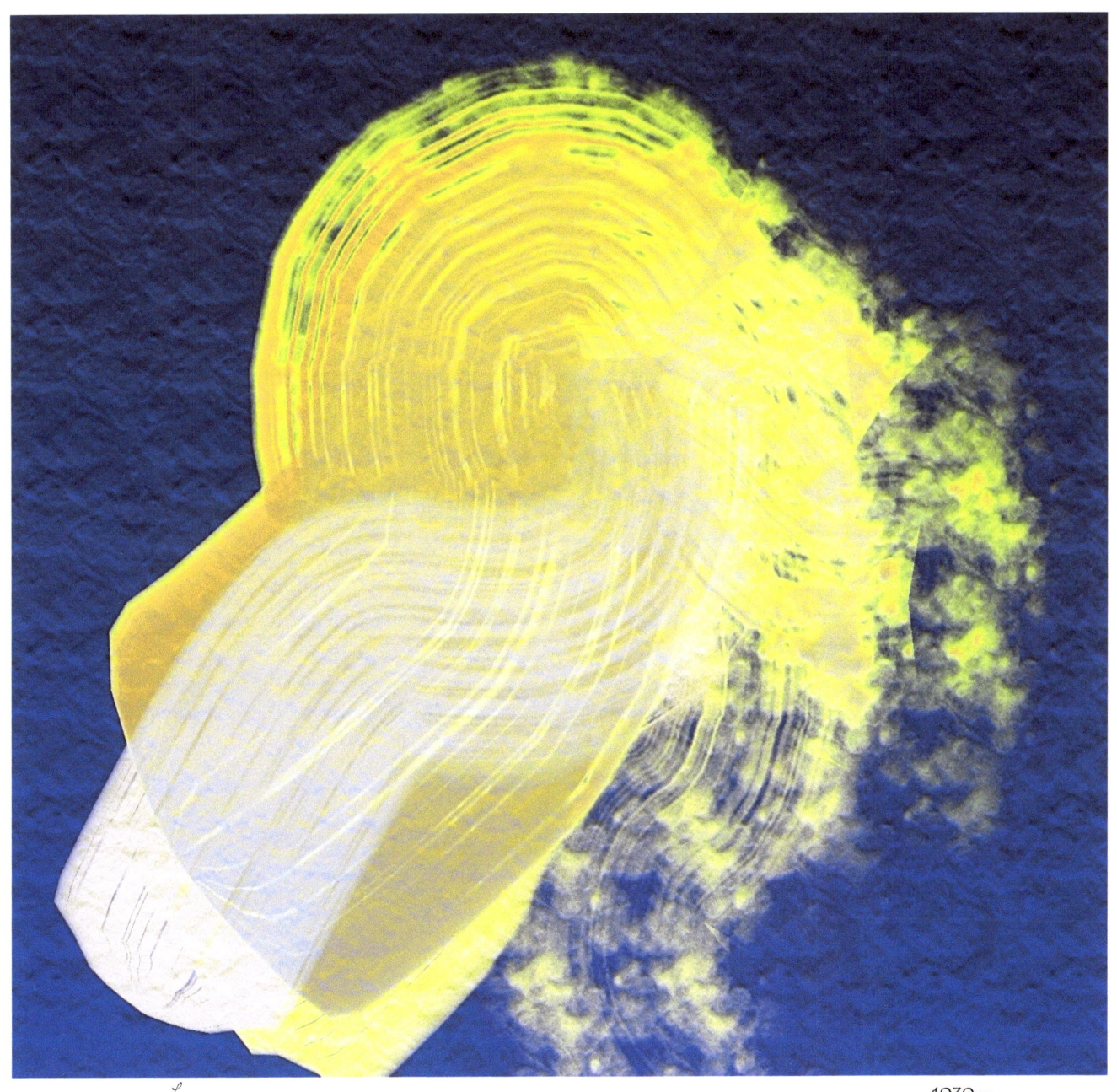

Lawrence 1030xe

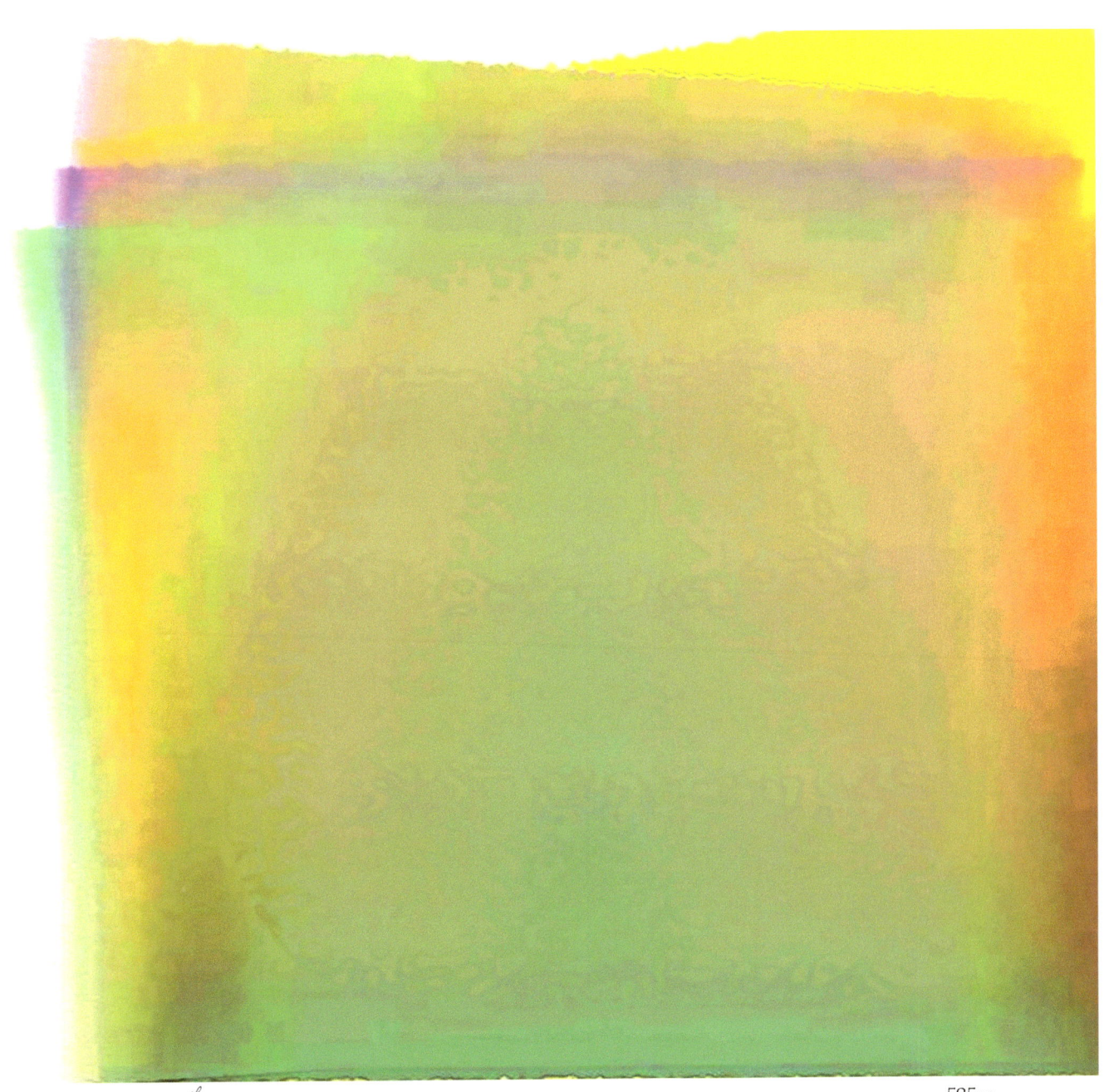

Lawrence 585xc

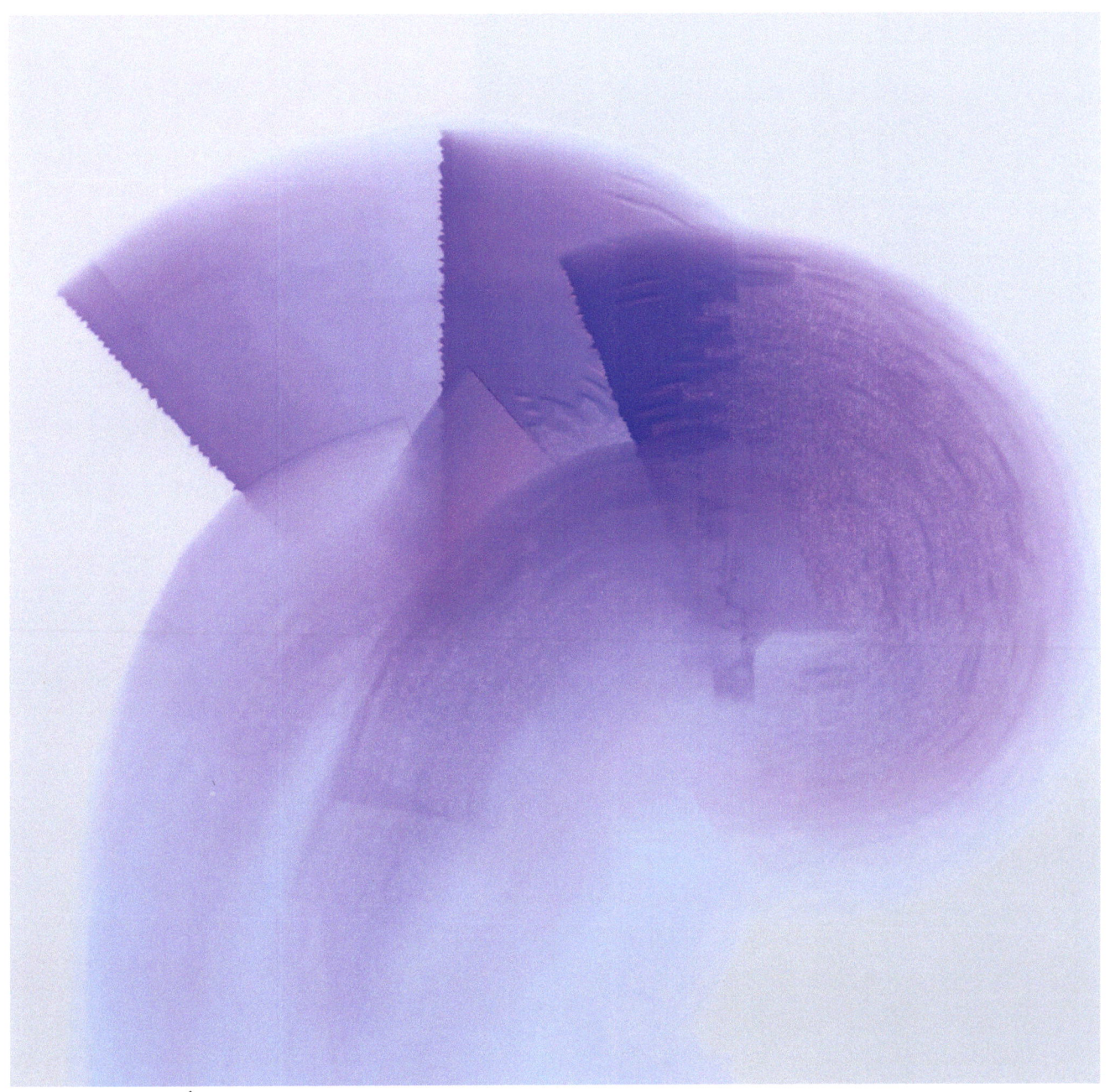

Lawrence 810xa

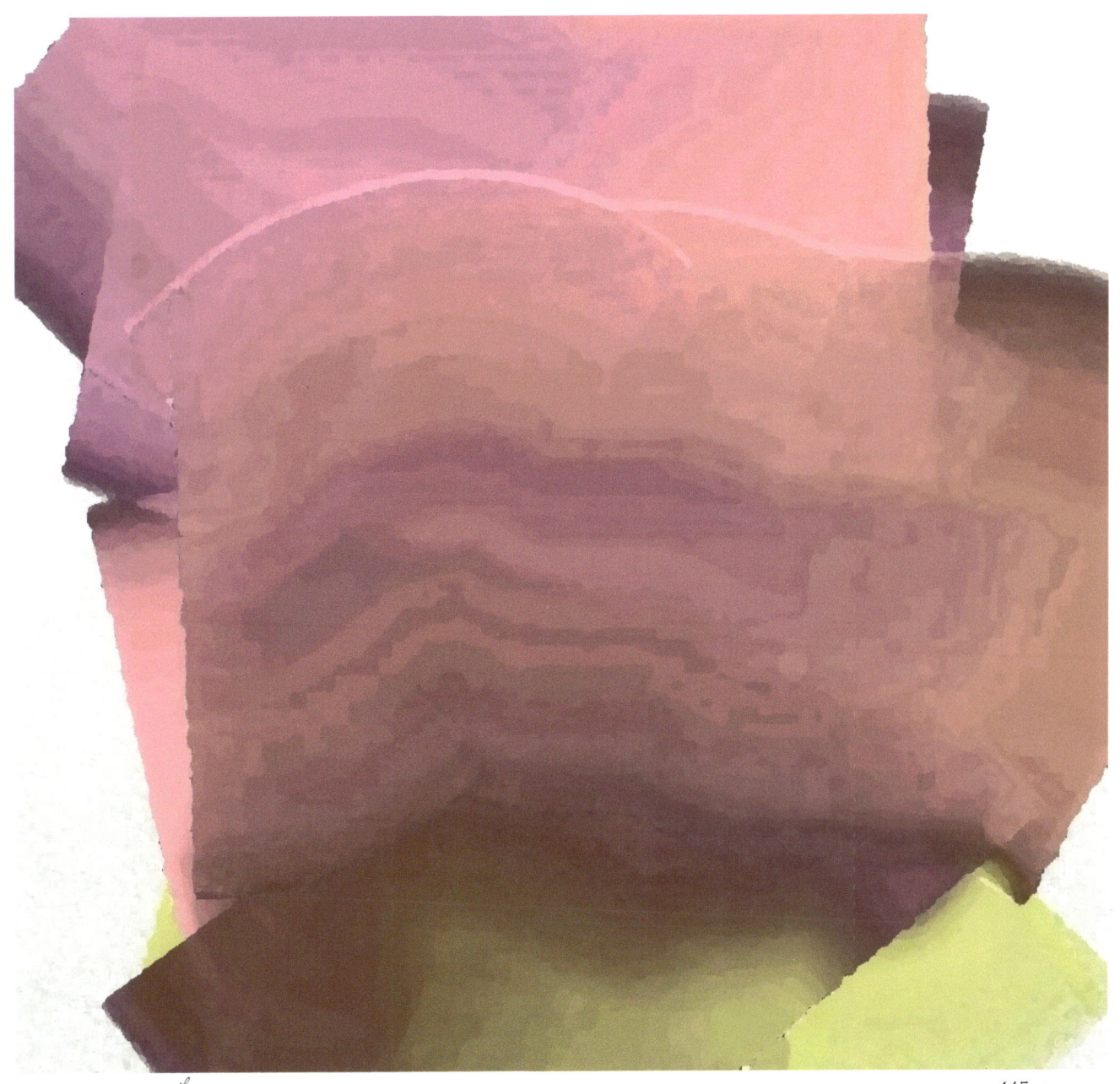

Lawrence 145xc

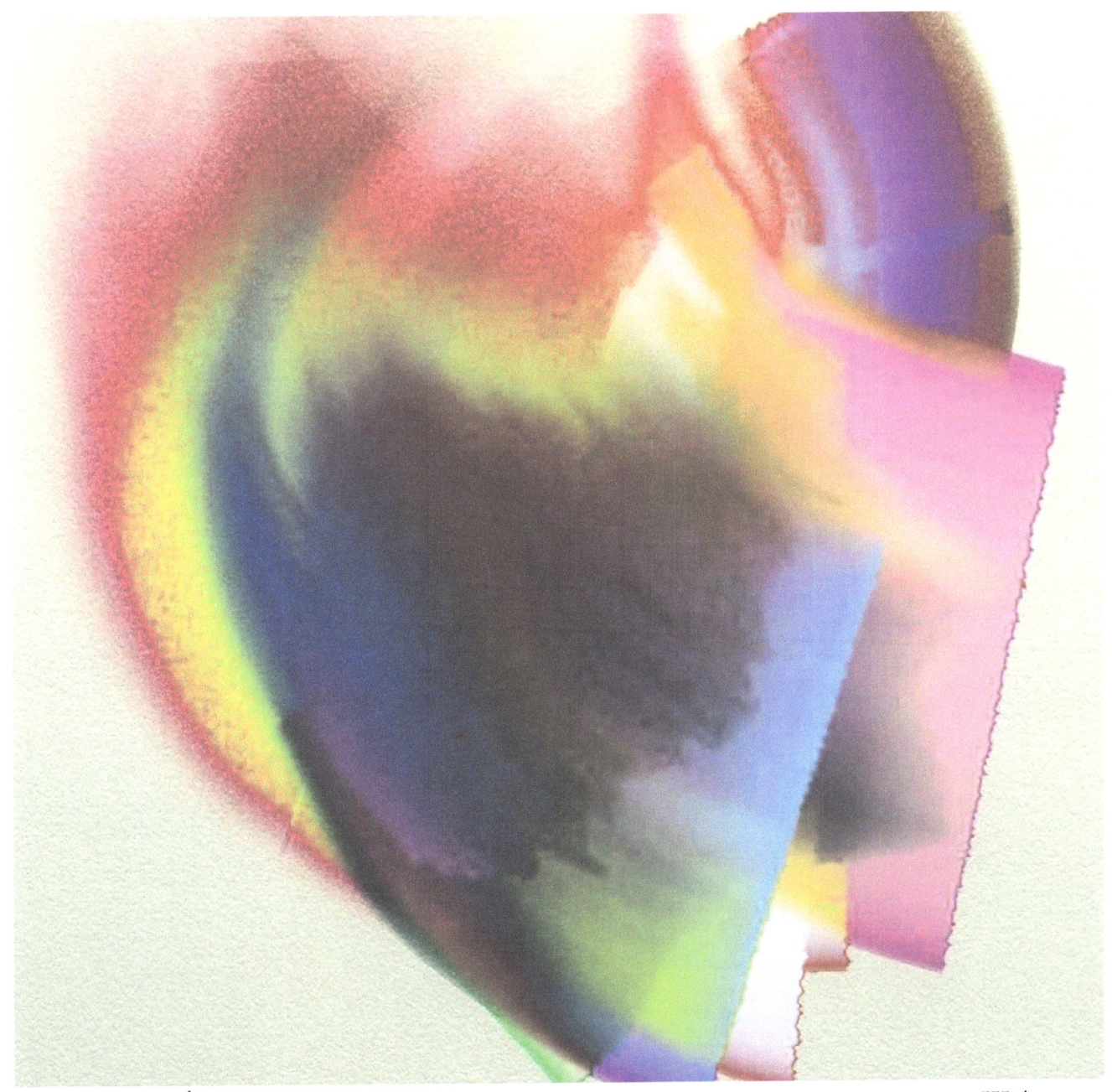

Lawrence 355xd

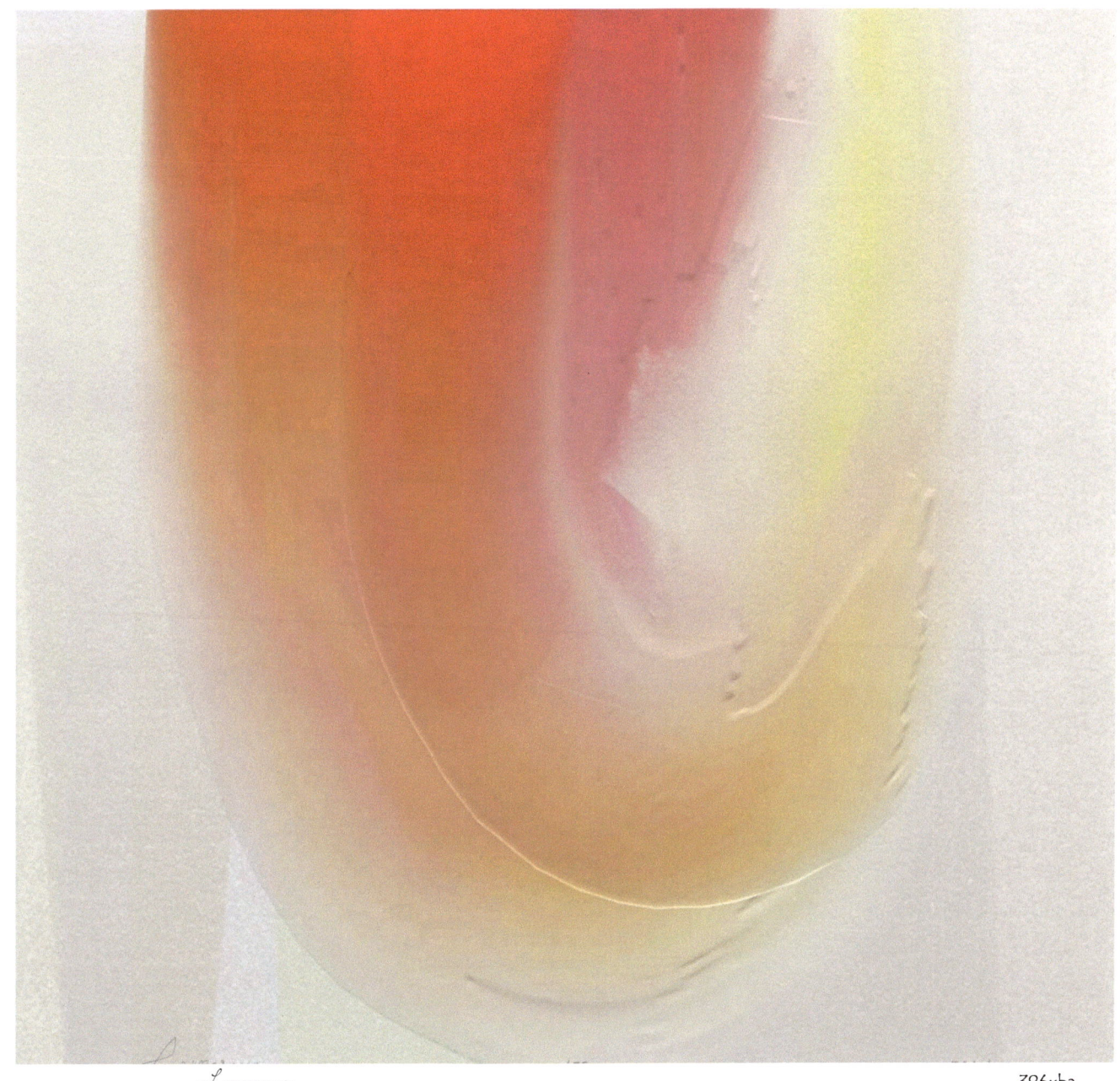

Lawrence 386xba

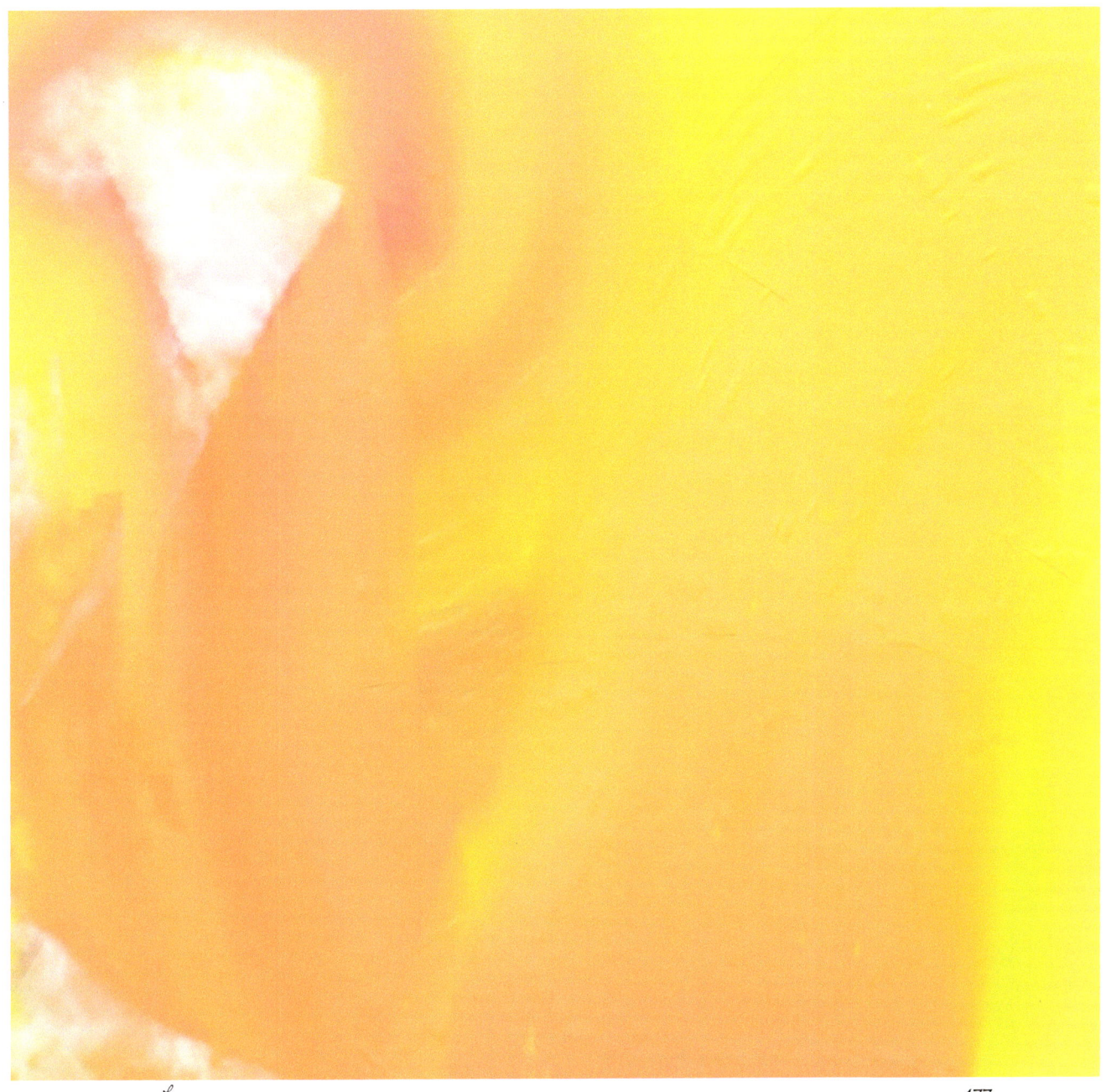

Lawrence 177x

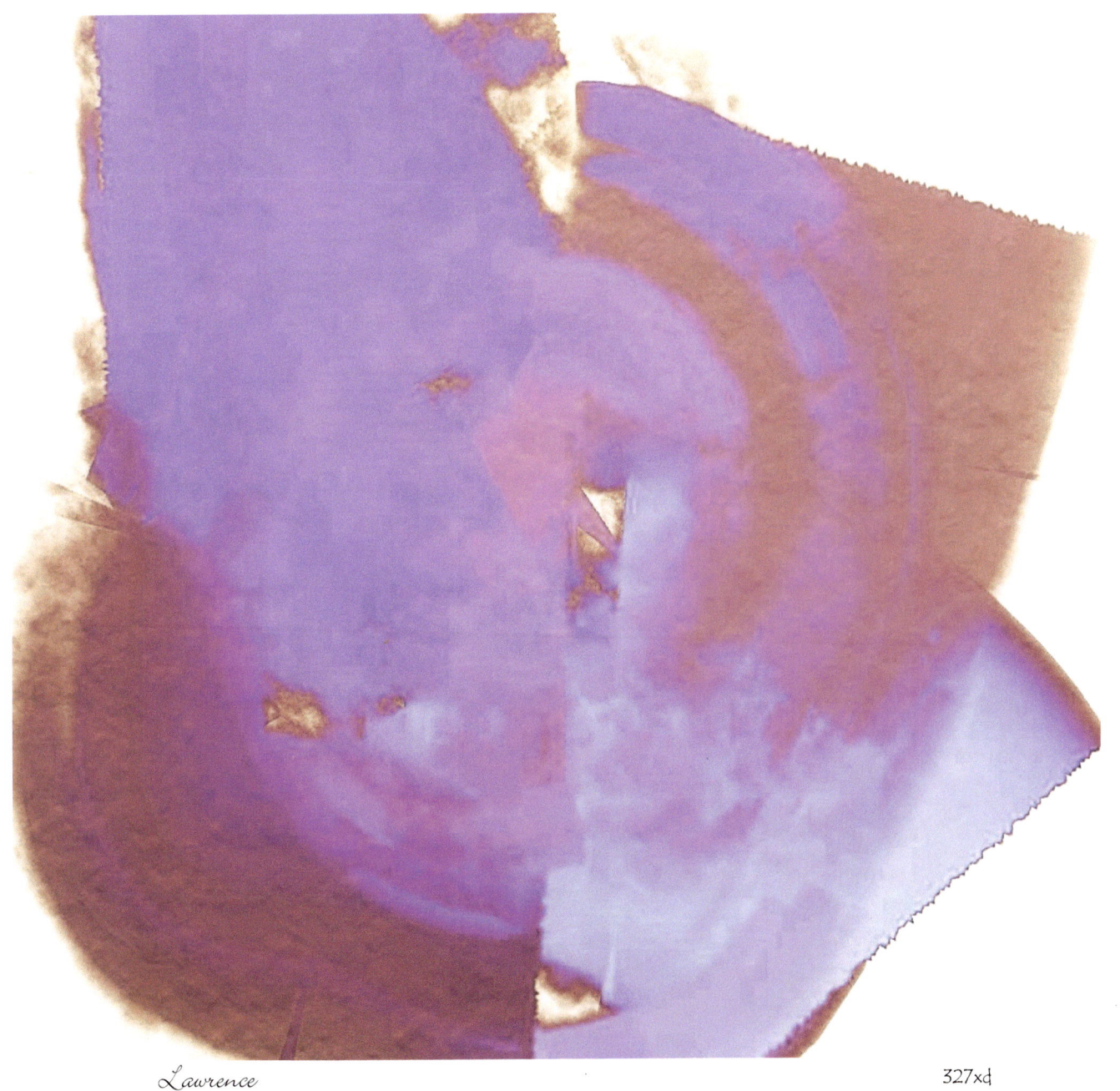

Lawrence 327xd

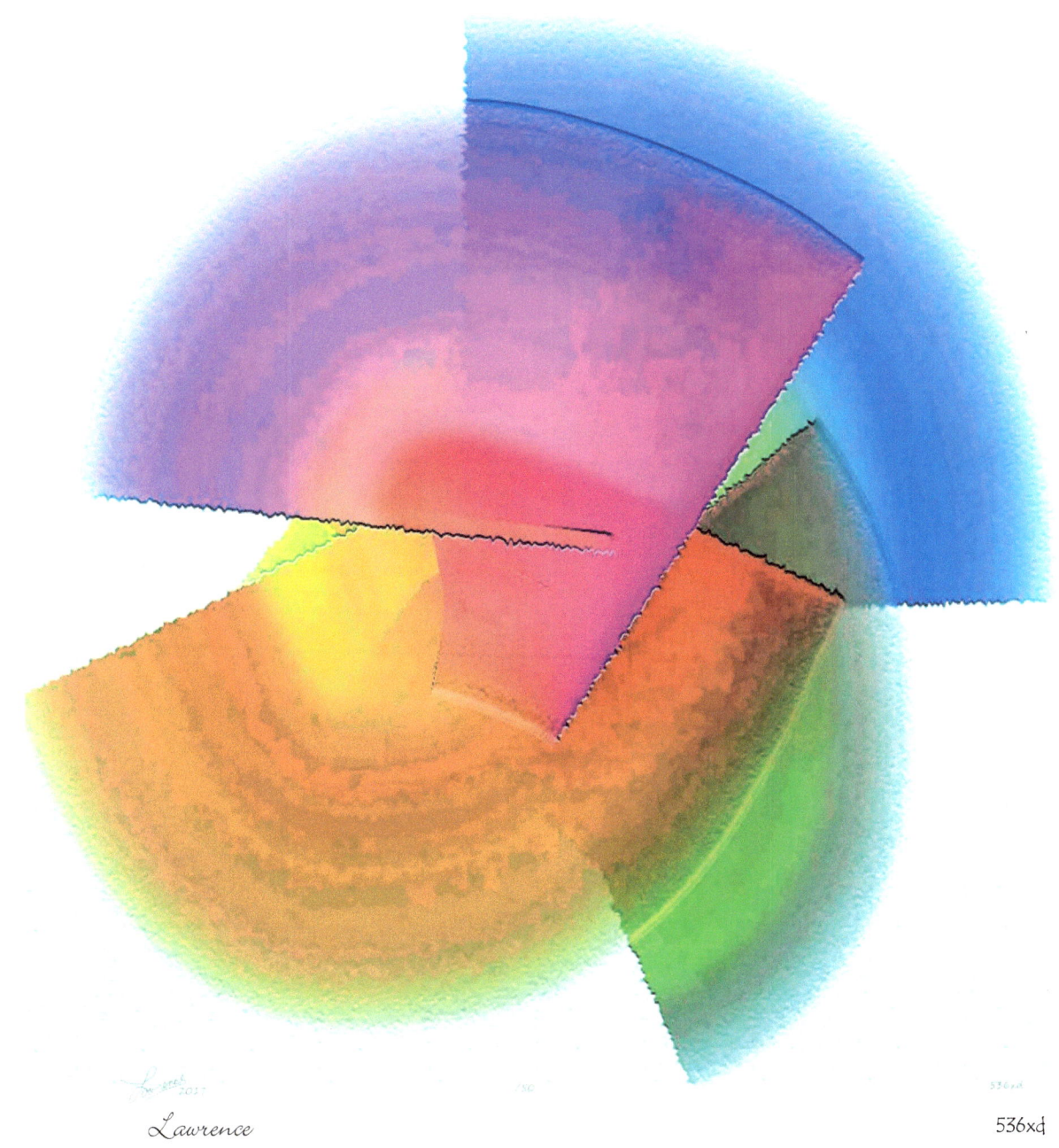

Lawrence 536xd

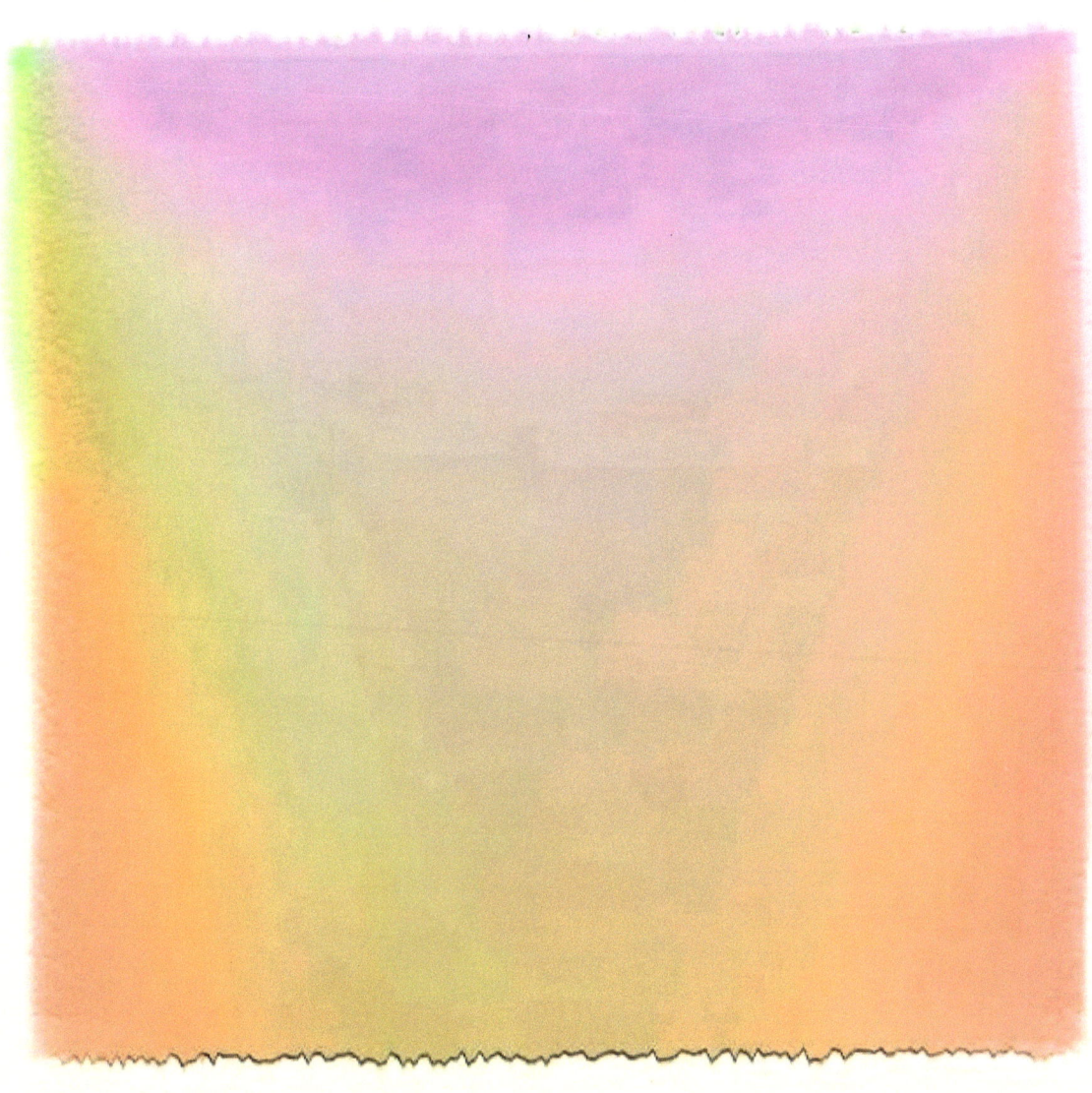

Lawrence 546xad

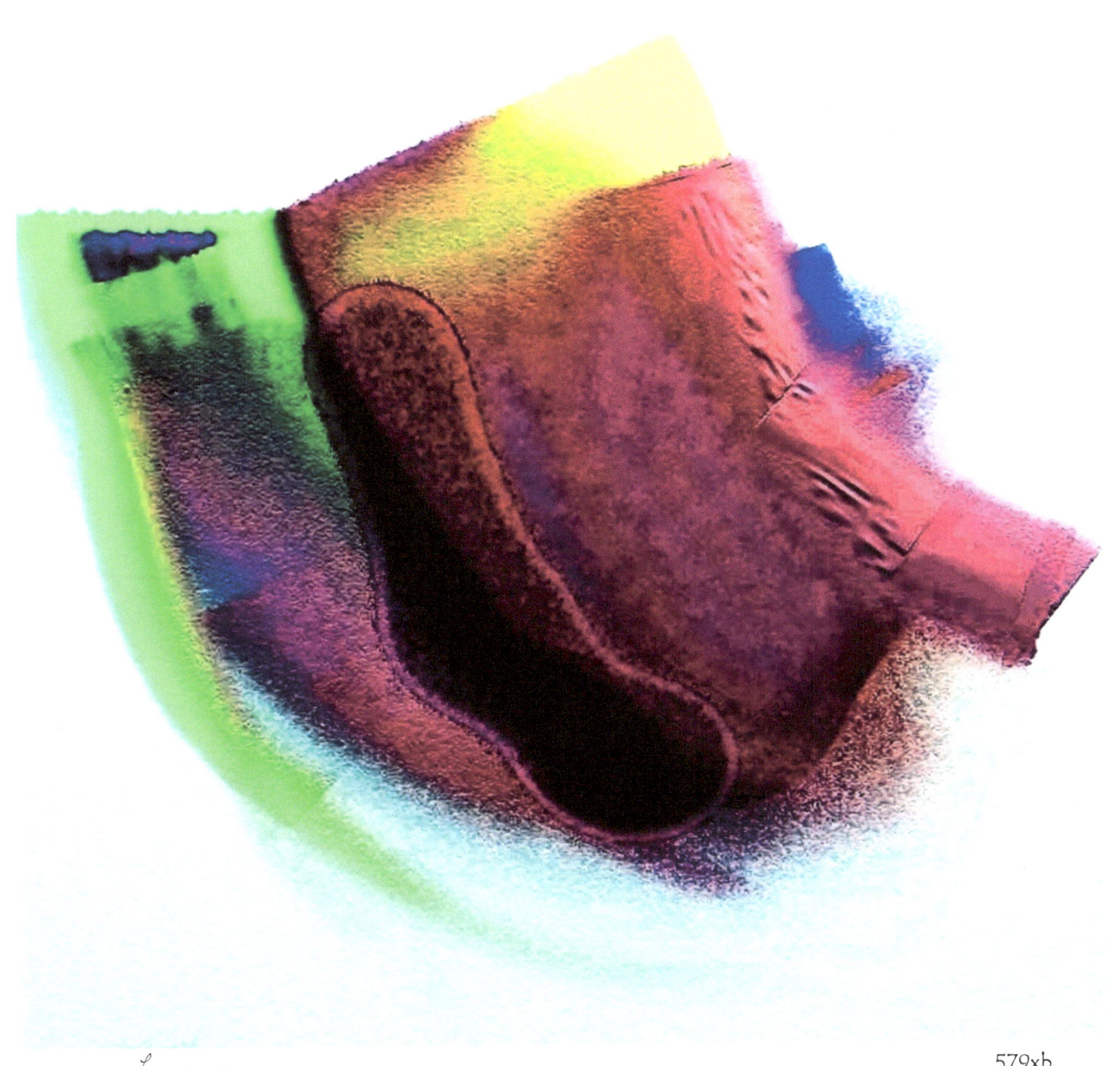

Lawrence 579xb

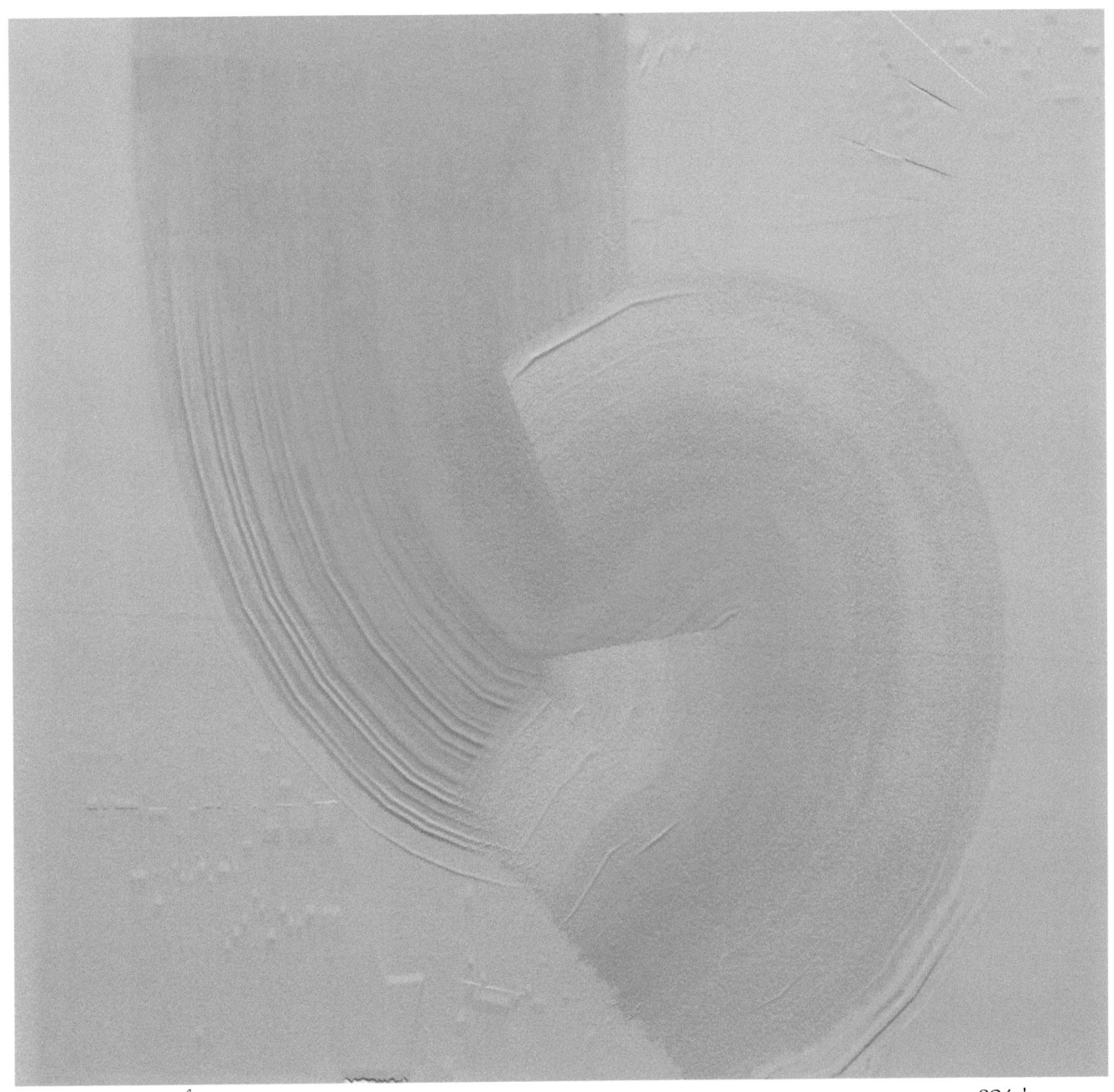

Lawrence 804xb

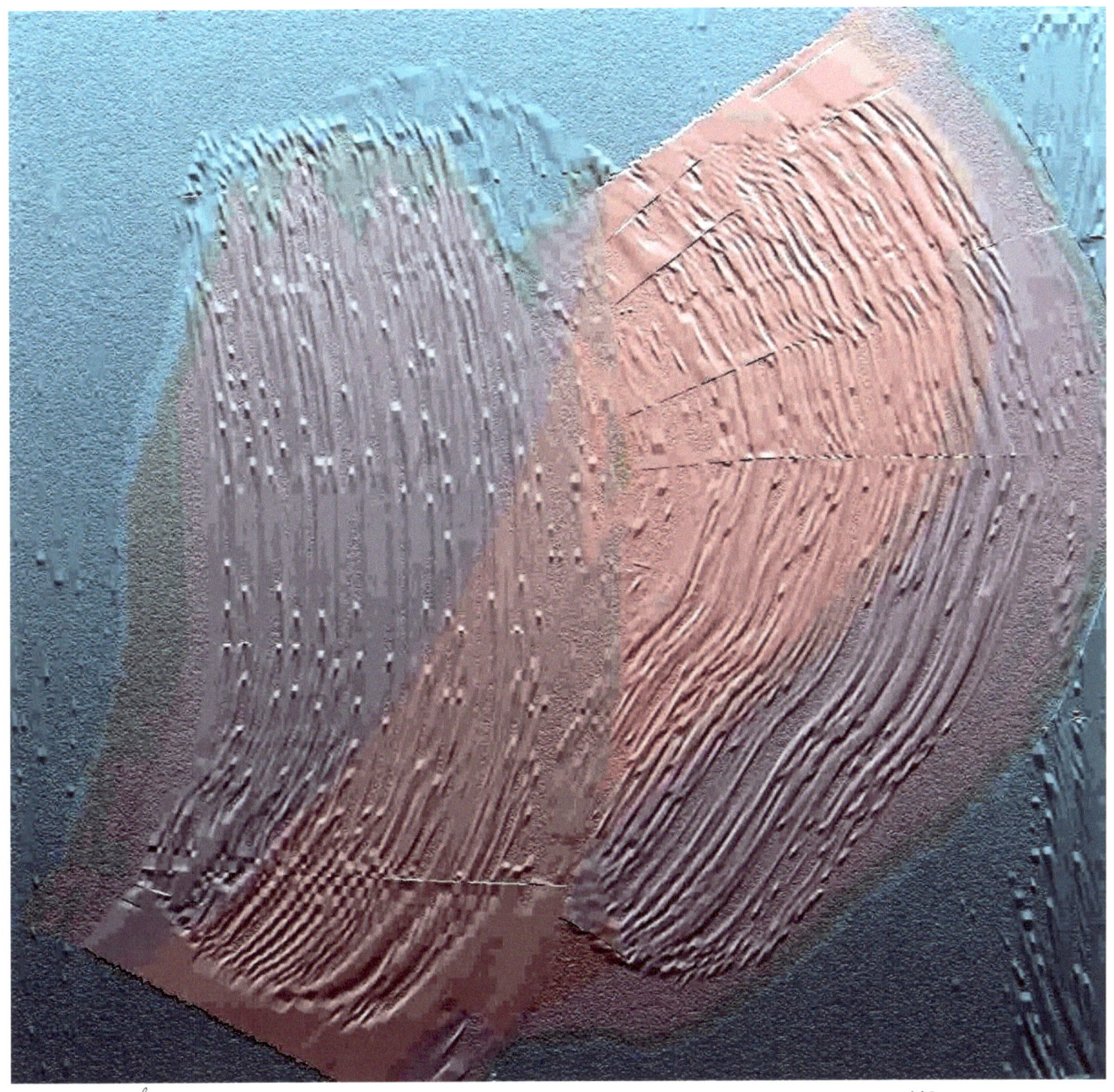

Lawrence 668x

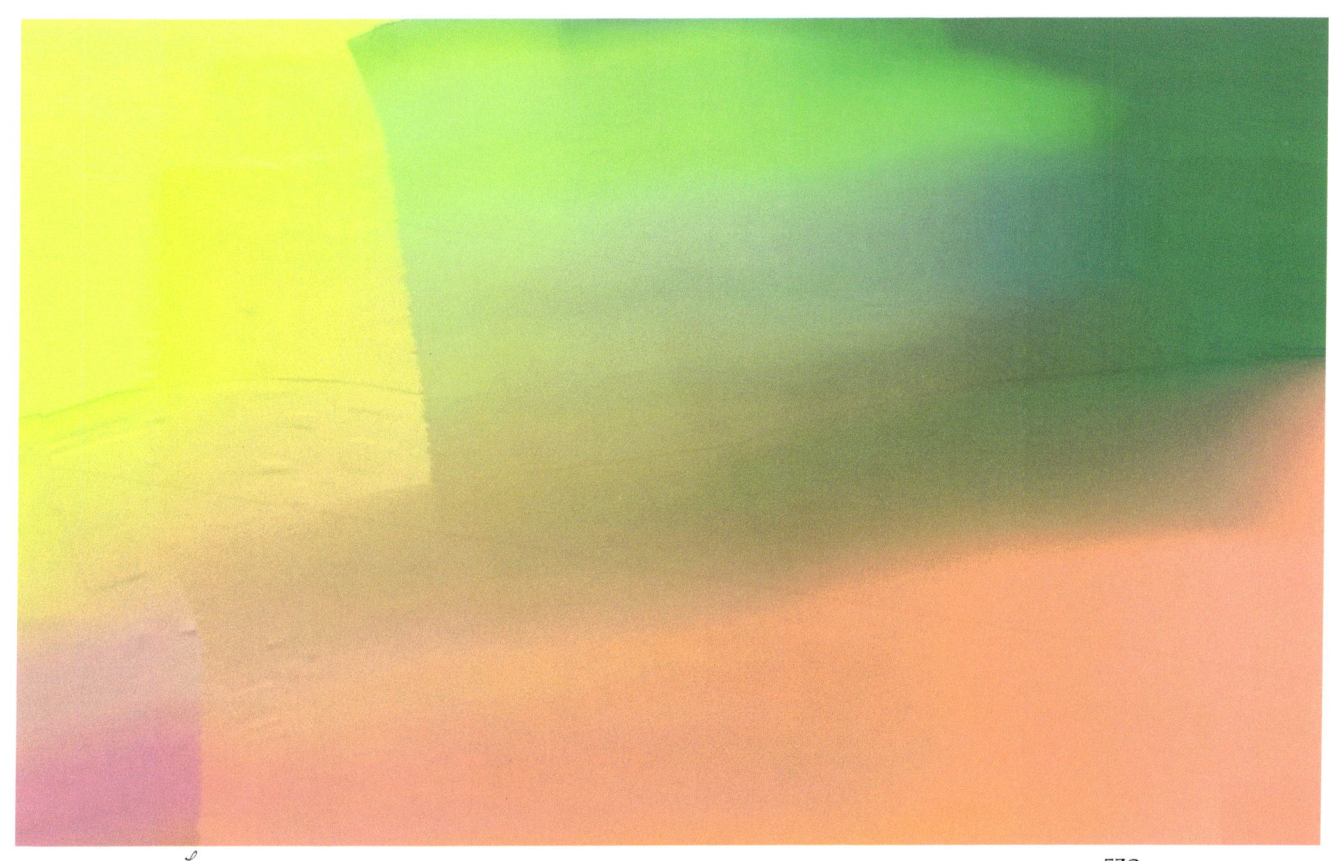

Lawrence 530x

By the year 1983 Lawrence had received a degree in Counseling Psychology and Studio Art from the University of Missouri adding to his previous studies in English, History, Psychology, Philosophy and Theology at Immaculate Conception Seminary, Conception, Missouri (1960-1968). An appreciation for nature, begun and nurtured on his father's farm in Kansas, is now nourished on the pinon filled hills and mountains; on the blue, blue skies, hot sun, cool winds; on the dry, richly marbled, rocky earth; on the varied traditions of Santa Fe New Mexico.